Painted Splendor

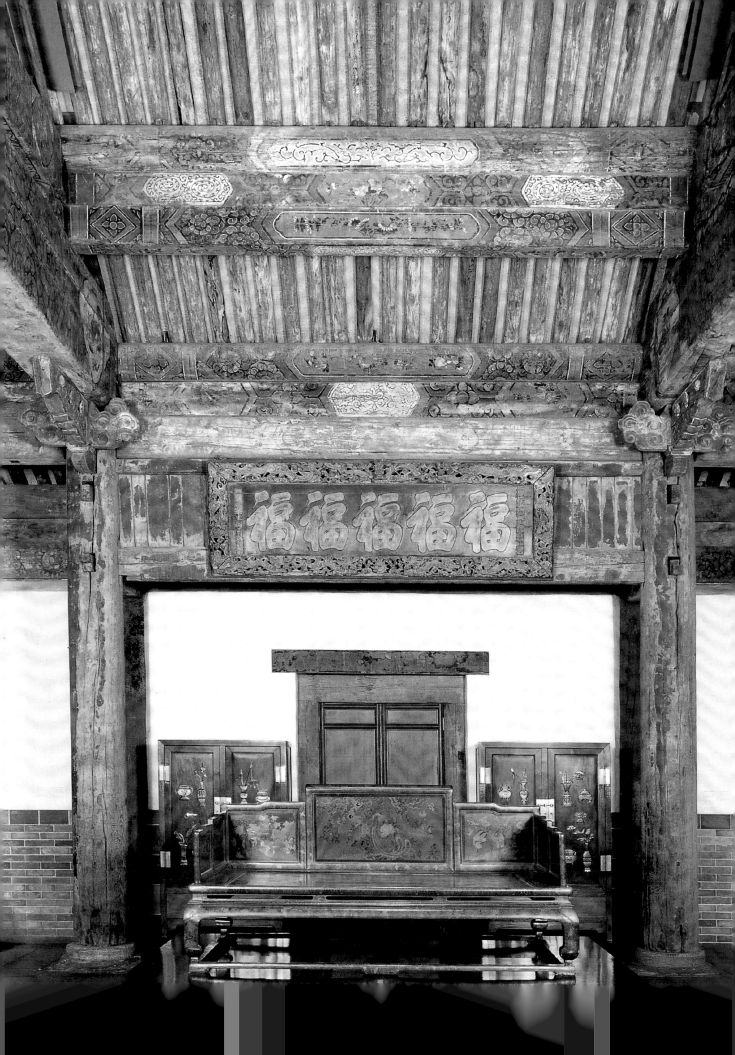

Painted Splendor

The Context and Conservation
of a Chinese Reception Hall
in the Philadelphia Museum of Art

Adriana Proser
Assistant Curator
East Asian Art

Sally Malenka
Conservator
Decorative Arts and Sculpture

Beth A. Price
Senior Scientist
Scientific Research and Analysis

With a Foreword by
Klaas Ruitenbeek
Louise Hawley Stone Chair of Far Eastern Art
Royal Ontario Museum, Toronto

Winter 2004, Volume 92, Numbers 389–90

This publication is supported by an Andrew W. Mellon Foundation
grant for the documentation of conservation projects.

The *Bulletin* is an occasional publication of the
Philadelphia Museum of Art
2525 Pennsylvania Avenue
Philadelphia, Pennsylvania 19130
USA
www.philamuseum.org

Produced by the Department of Publishing
Designed by Bessas & Ackerman, Guilford, Connecticut
Color separations by Professional Graphics, Inc., Rockford, Illinois
Printed and bound by Meridian Printing, East Greenwich, Rhode Island
Printed in the United States of America

Distributed by Art Media Resources, Inc.
www.artmediaresources.com

ISBN 0-87633-177-0

Photography and Illustration Credits:
Sally Malenka and Beth Price: Figs. 29, 31–34
Joe Mikuliak: Figs. 9–12, 14–20, 24–28, 35–37, page 30
Philadelphia Museum of Art Archives: Figs. 2–6, 22
David Noble: Figs. 7, 8, 23
Graydon Wood: Cover, frontispiece, fig. 1

Cover: Detail of the reception hall's interior roof beams
and other architectural elements at the Philadelphia Museum of Art

Frontispiece: Detail of the reception hall interior installed
in the Museum, as viewed from the main entrance

Page 30: Scaffolding erected in the reception hall
during the 1995–96 conservation treatment

Preface

Philadelphia has been known since the seventeenth century for the distinction and variety of its architects and architecture. The present building of the Philadelphia Museum of Art, both in its exterior and its interior, is a prime example of the city's architectural ambitions and achievements. Shortly after the building opened in the spring of 1928, Fiske Kimball, the gifted architectural historian and Director of the Museum at the time, sent Horace H. F. Jayne, curator of Asian art, to Japan and China to acquire outstanding examples of architecture from those countries for the Museum. Jayne succeeded brilliantly. The story of one of the five architectural interiors he obtained, the Ming dynasty reception hall from Beijing, is recounted and amplified in the essays that follow.

Architecture gives us a tangible, physical experience of Chinese culture, and our visitors' perceptions of China have surely been shaped in part by the Museum's reception hall for several generations. The grand scale of the structure, with its massive, ornately painted woodwork, inspires awe; the symmetrical windows and columns reflect the rationality and ideal harmony of Confucian society; all these elements converge to impress the visitor with the status and wealth of the reception hall's original owners.

The publication of this special double issue of the Museum's *Bulletin* coincides with the seventy-fifth anniversary of the acquisition of the reception hall. It also celebrates the completion of the major project to conserve the magnificent painted decoration. This project began in 1985 with a conservation survey funded by the National Endowment for the Arts. The prolonged and careful process of materials research, cleaning, and consolidation was carried out by a skilled team under the supervision of Sally Malenka, Conservator of Decorative Arts and Sculpture, with scientific analysis headed by Beth Price, Senior Scientist. The impressive results of these efforts were achieved thanks to support from the Institute of Museum Services and The Women's Committee of the Philadelphia Museum of Art. The Women's Committee also ensured that the success of these extensive conservation efforts would not go unnoticed by funding the relighting of the gallery in 2003.

We thank the authors of the essays that follow for their thoughtful contributions. In his Foreword, Klaas Ruitenbeek of the Royal Ontario Museum places the reception hall in the context of the official style of architecture that was practiced in China during the Ming and Qing dynasties. Adriana Proser, this Museum's Assistant Curator of East Asian art, sheds new light on the history and ownership of the hall and describes

in detail its elegant painted motifs. Sally Malenka and Beth Price document the research, planning, and implementation of their innovative conservation treatment to preserve this unique architectural installation.

This publication is supported by a grant from the Andrew W. Mellon Foundation to enable the results of collaborative conservation and curatorial research into the Museum's collections to reach a wide audience. We are deeply grateful not only for the Mellon Foundation's generosity but also for its enlightened and steadfast commitment to the mission of American art museums to conserve, study, and publish their treasures.

ANNE D'HARNONCOURT
The George D. Widener Director
and Chief Executive Officer

P. ANDREW LINS
The Neubauer Family Chair of Conservation
and Senior Conservator of Decorative Arts and Sculpture

FELICE FISCHER
The Luther W. Brady Curator of Japanese Art
and Curator of East Asian Art

Foreword

The Ming dynasty reception hall in the Philadelphia Museum of Art is well known as an exceptional monument of Chinese architecture. When the painted decoration in the hall was subject to a major conservation treatment in 1995–96, Museum conservator Sally Malenka, scientist Beth Price, and asssistant curator Adriana Proser conducted important new research with regard to its history and painted decoration. The results of their investigations, published here, show once more that the fame of the Museum's hall is fully deserved. As a curator at the Royal Ontario Museum, another institution that houses a treasure of Chinese architecture—a large Ming dynasty tomb—it is not only a great pleasure for me to write this foreword but also quite fitting.

A reception hall is a *Yang* house, a house for the living, while a tomb is a *Yin* house, a house for the dead. Through concepts of geomancy and ancestral cult, *Yang* houses and *Yin* houses are closely connected in Chinese thought. In their original setting, they could be located quite far apart, although not as far apart as Philadelphia and Toronto. However, the princes who lived in the mansion of which the reception hall was once a part would have made offerings several times a year at an ancestral tomb complex very similar in size and appearance to the one in the Royal Ontario Museum.[1]

The Philadelphia Museum of Art's reception hall is representative of the official-style architecture of the Ming and Qing dynasties (1368–1644 and 1644–1911, respectively). This style was used primarily for palaces, imperially sponsored temples, and imperial tomb architecture in the metropolitan area of Beijing. While official-style architecture changed considerably during the thousand years before the Ming dynasty (just as European architecture developed from early Romanesque to late Gothic during roughly the same period), virtually nothing changed after 1368, when the official style became codified and buildings of the same type were built and rebuilt following a modular plan. In a highly bureaucratized environment, master carpenters, palace eunuchs, and government officials supervised the technical, logistical, and financial aspects of a construction project. The earliest surviving building in the official style, the large hall in front of the Yongle emperor's tomb from 1409, appears hardly different from one of the latest examples, the architecture at the tomb of Empress Dowager Cixi, who died in 1908. The Museum's reception hall, constructed around 1640, falls roughly in the middle of this five-hundred-year period and is thus a telling example of the constancy of the official style.

The stone platforms, timber structure, and tiled roofs form the most lasting parts of official-style Chinese buildings, and the uniformity of their construction is well docu-

mented. However, it is difficult to know if the painting applied to any particular timber frame remained the same over time, since, as part of a well-regulated bureaucracy, all buildings were routinely repaired and repainted. The closer a building was to the imperial throne—the center of the Chinese universe—the more frequent were these overhauls, and the more important it was to adhere strictly to the most recent version of the official building regulations. Thus, although the imperial complex of the Forbidden City in Beijing still includes a few original Ming dynasty structures, none retain their original Ming painted decoration. Instead, virtually all were redecorated in the two main painting styles prevalent during the Qing dynasty: the "whirling flower" style and the more lavish "hexi" style, in which gilded dragons and phoenixes are the predominant motifs.[2]

The extent to which these painting styles were officially codified is evident in the building regulations of the Qing dynasty. First printed in 1734, the regulations prescribed the quantities of the various pigments required to paint every wooden part of a building as well as the number of hours it should take a painter to do the work. Similar regulations must have existed in the Ming and the early Qing dynasties, but they have not been transmitted. However, these earlier regulations, which concerned the painted decoration of an interior, were probably quite different from those outlined in 1734. This is suggested not only by the different painting styles of the Philadelphia Museum of Art's reception hall but also, and very clearly, by the Meridian Gate—the imposing, U-shaped southern entrance to the Forbidden City. When major conservation work was done at the gate in 1976–78, remains of painted and gilded decoration in a completely different style, dating back to the early Qing or late Ming dynasty, were discovered in the interior. On the basis of this documentation, the entire structure was redecorated in this earlier style and, as a result, the gate now looks quite different from the other edifices in the Forbidden City.[3]

A rather fortuitous combination of circumstances led to the survival of the Philadelphia Museum of Art's reception hall. First, the continuous repairing and repainting of palaces and temples acted as a major drain on the treasury; therefore, it is not surprising that the Imperial Household Agency paid less attention to the upkeep of the more remote princely palaces of the Imperial City (the walled city of Beijing surrounding the Forbidden City), such as that of Prince Li, from which the Museum's reception hall comes. Furthermore, during the Qing dynasty, the rank of members of the nobility decreased with every generation. The first Prince Li, who moved into the palace, was a prince of the first degree. Theoretically, after twelve generations, his descendants would have been princes of the twelfth, or lowest, degree. Decrease in rank meant a lower stipend and less means to upkeep and embellish the mansion.[4] This neglect, in turn, created ideal conditions for the preservation of old layers of paint. Finally, it proved extremely fortunate that a Ming hall from the Imperial City was brought over to Philadelphia in 1929, before the rapid economic development and modernization of Beijing erased virtually all other surviving examples.

This volume is essential reading for anyone who is interested in the history of Chinese architecture. As the only significant example of palace architecture outside China, the Philadelphia Museum of Art's reception hall gives us a rare chance to see and experience the splendor of decorative painting in a style that is closely related to that of the late Ming or early Qing dynasties.

KLAAS RUITENBEEK
Louise Hawley Stone Chair of Far Eastern Art
Royal Ontario Museum, Toronto

Notes

1. The Royal Ontario Museum's Ming tomb reportedly belonged to Zu Dashou (died 1656), a Ming general who was defeated in 1642 by Abahai, the first emperor of the Qing dynasty. It was originally situated near Fengtai, southwest of Beijing, and consists of a stone mound, a stone altar table, two stone guardians, two stone camels, and two stone gates. George Crofts acquired the objects for the museum in 1919.

2. Institute of the History of Natural Sciences, comp., "The Art of Architectural Decoration," in *History and Development of Ancient Chinese Architecture* (Beijing: Science Press, 1986), pp. 252–88, figs. 8.3.4, 8.3.14.

3. Wang Yizhang, "Gugong Wumen caihua de fuyuan" [The Restoration of the Painted Decoration of the Meridian Gate], *Gugong Bowuyuan Yuankan*, no. 4 (1979), pp. 87–91; Yu Zhuoyun (retired conservation architect of the Forbidden City), conversation with author, summer 1996. For photographs, see Yu Zhuoyun, comp., *Palaces of the Forbidden City*, trans. Ng Mau-Sang, Chan Sinwai, and Puwen Lee (New York: Viking, 1984), pp. 36–37.

4. Susan Naquin, *Peking: Temples and City Life, 1400–1900* (Berkeley and Los Angeles: University of California Press, 2000), pp. 389–95.

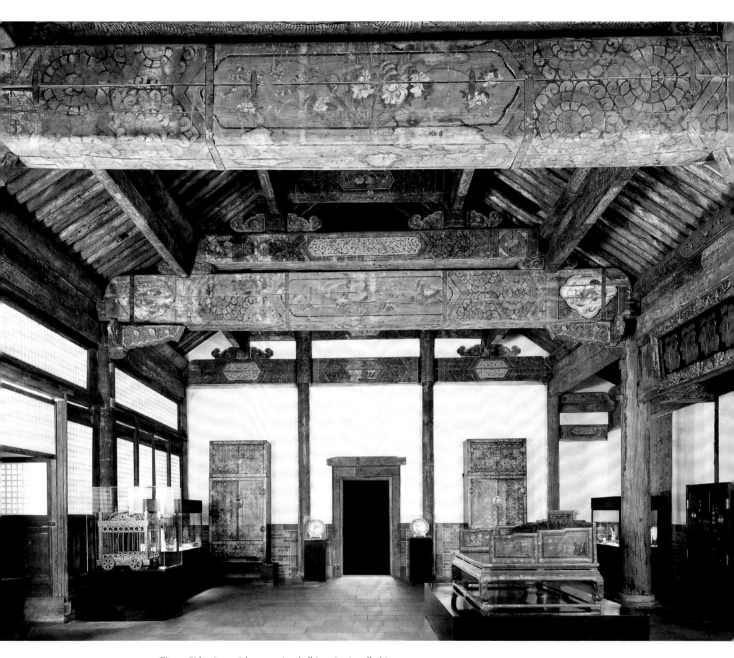

Fig. 1. Side view of the reception hall interior installed in
the Museum. Visitors to the original palace would have
entered from the main entrance, seen here on the left.
The reception hall as it appears today in the Museum
reveals many of the principal characteristics of Chinese
palace architecture, including exposed wood construction
emphasized by elaborate and colorful painted decoration.

A Chinese Reception Hall
from the Palace of Duke Zhao

ADRIANA PROSER

"Most Chinese think you're a fool to want to buy an old room when you could have a new one built for half the price and far less trouble," wrote Horace H. F. Jayne, the Museum's first curator of Asian art, during a buying trip to China in 1928.

"Here in Peking," he reported in the same letter to the Museum's director, Fiske Kimball, "I have so far been occupied with establishing connexions which may lead to the purchase of suitable interiors; inasmuch as there is no market for these . . . it is no easy task to negotiate these matters. . . . I am engaged upon bargaining for . . . a chamber of truly superb proportions with immense wood beams supporting the roof all with handsomely carved brackets and remnants of the old colours [fig. 1], fine pillars and excellently patterned windows. . . . It comes from a Ming palace and is fully documented as to date and ownership. Ming palaces are not many in Peking and this one even is falling into decay very rapidly with no one but coolies occupying odd corners of it. I am sure this room if I get it will create a sensation when it is shown in the New Building."[1] With this letter begins the Museum's chapter in the history of the reception hall from the Palace of Duke Zhao (Zhaogongfu), an extraordinary example of Chinese architecture (fig. 2). Soon after he wrote to Kimball, Jayne was able, with generous funds provided by Edward B. Robinette, to complete the negotiations to buy the room and have it shipped to Philadelphia, where it would be transformed into the centerpiece of the Museum's East Asian collections.

The reception hall is unique in the United States. In fact, it is the only original example of a Ming dynasty (1368–1644) reception hall interior with painted decoration to be found in any museum in the West. Its presence at the Philadelphia Museum of Art owes much to the grand vision of Fiske Kimball, director from 1925 to 1955 (fig. 3). Kimball envisioned the Museum as a place where exceptional period architecture and interiors would stand as works of art in their own right. He also saw them as significant educational

Fig. 2. Interior view of the reception hall in Beijing, 1928

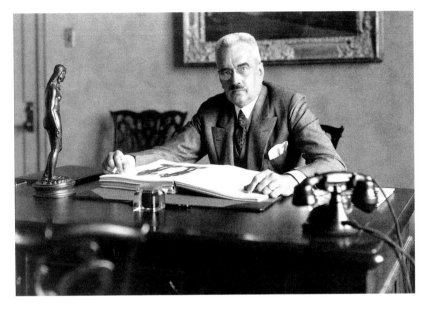

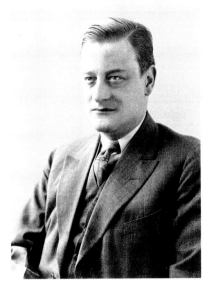

Fig. 3. Fiske Kimball, the Museum's director (1925–55), ca. 1938

Fig. 4. Horace H. F. Jayne, the Museum's first curator of Asian art (1921–40), purchased the reception hall for the Museum during a trip to China in 1928.

tools that would provide historical context for the display of art objects. Under his direction, the Museum's collections grew to include American, European, and Asian architectural elements from many periods. When Kimball sent Jayne (fig. 4) to China in 1928, Jayne learned of the availability of several buildings and made arrangements for their purchase and transportation to Philadelphia. His acquisitions included the reception hall, a carved and painted ceiling from the Ming dynasty Buddhist Temple of Wisdom, and a Qing dynasty scholar's study. Once installed at the Museum, these interiors all became settings for the display of Chinese paintings, sculptures, ceramics, and other decorative arts.

Jayne traveled to China soon after the capture of Beijing (Peiping) by Chiang Kai-shek's Nationalist government.[2] While there, he and his assistant, Isabel Ingram, encountered considerable difficulty finding and purchasing a room from a Chinese palace. However, by October he cabled to Kimball that a building was available for $8,200 (the equivalent of about $81,000 today)—a price that included dismantling, packing, and duty charges.[3] In his colorful account, Jayne mentions that he had his eye on two possibilities, each with its own problems. One was "owned by an opium smoker who will not close any deal until he actually needs money for more opium, and he has still a few weeks supply on hand."[4] The other was just as good but more expensive and larger, and therefore more difficult to dismantle and re-erect. The correspondence is unclear about which of the two buildings he finally purchased, but an early photograph in situ of the one Jayne acquired shows it in a general state of disrepair, with vegetation growing on the roof (fig. 5). Jayne noted that the reception hall

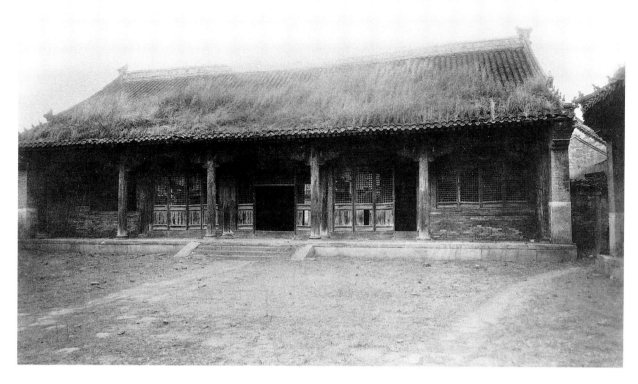

Fig. 5. Exterior view of the reception hall's main entrance in Beijing, 1928

would "not be easy to re-erect in the Museum," but that he would "have careful plans made and photographs taken," making it "by no means impossible in spite of its size."[5]

Edith A. Punnett, the Beijing dealer who was responsible for closing Jayne's sale transactions, had her own problems with the owners of the building. After Jayne returned to Philadelphia, she wrote to him in February 1929: "Even at the last minute, when I went to see the contract signed . . . , it seemed as if it would all fall through. One of the brothers (there are about a dozen relatives interested) made a scene and refused his consent. . . . An Aunt before did not want to give the stone plinths and it took from 4–10 p.m. to persuade her! Those are samples of the aggravating and unreasonable opposition the family has given. All of which meant squeeze [bribes] to the intermediaries who had to be called in to persuade the objectors."[6] When the final agreement was made at last, Punnett hired a contractor, who dismantled the building and was eventually persuaded to pack it for transportation. The elements of the reception hall, carefully wrapped in oilcloth, were shipped to Philadelphia on the SS *Havre Maru*, arriving in the summer of 1929.[7]

When Punnett notified Jayne of the purchase, she wrote optimistically: "I hope you will have no difficulty in rebuilding the palace. An old carpenter here said there is a great deal that is different from modern construction and offered to go to America to show how to put it together! So you know where to come if you need help!"[8] But the reception hall would remain in storage at the Museum for eight years before anyone could reassemble it. Installation of this impressive room would occur against the backdrop of the Depression, when the interior of the Museum's new building was moving toward

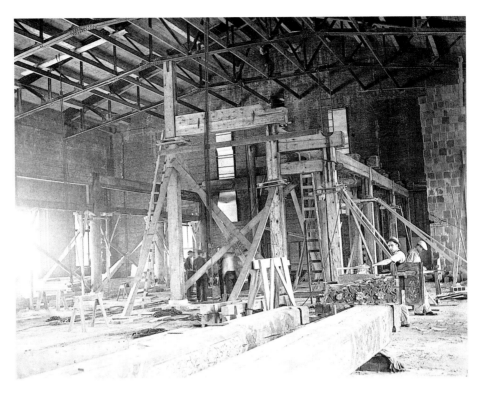

Fig. 6. Works Progress Administration workers installing the reception hall interior on the second floor of the Museum in July 1937. The reception hall opened to the public almost three years later.

completion. Construction on the Museum itself had begun in 1919, and by March 1928, when the building opened to the public, only ten galleries of British and American art were finished. In 1931 the galleries of medieval art were unveiled. When interior construction work stopped in 1932 due to a lack of funds, only one-sixth of the Museum's vast space was completed. With construction still at a halt in 1935, the Museum administration sought the aid of the Works Progress Administration (WPA), and work on the building resumed that November. Largely paid through WPA grants, laborers installed galleries and period rooms in the vacant space on the second floor, along with curatorial and administrative offices on the ground floor.[9] By the winter of 1936–37, a group of Dutch, German, French, and English period rooms in the north wing opened to the public.

When workers began to install the Chinese reception hall in 1937, they were confronted with the task of reconstructing a room that was 45 feet wide, 35½ feet deep, and 26 feet high at its peak. The two largest tie beams weighed more than two thousand pounds each, and the two largest columns weighed about one thousand pounds each. The installation was a remarkable feat; WPA workers hoisted and manipulated the cumbersome wooden beams and the numerous individual elements to fit together in the mortise-and-tenon construction. A photograph from the period shows laborers in the midst of the project and captures the elaborate scaffolding that was required to install such a large-scale interior (fig. 6).[10]

Some modifications had to be made to the structure so that the Museum could accommodate it. Originally, the reception hall had five bays, which included two flanking rooms at either end of the sidewalls, but only the central three bays were transported to and installed at the Museum. The side doors that formerly led to the flanking rooms were moved to the center of each sidewall and transformed into entrances and exits to accommodate the flow of visitors through the Asian galleries. To re-create the original appearance of the room, WPA workers installed brickwork, whitewashed walls, and stone floors.[11] Large lacquered cabinets and other decorative arts of the Ming and Qing dynasties were acquired and placed in the hall to establish greater historical context. After years of work, the reception hall, together with the new Asian wing, opened to the public on April 5, 1940.

A Brief History of the Reception Hall

In 1929, Punnett wrote to Jayne about the residential complex of which the Chinese reception hall was a part: "You probably know the historic interest of this palace—that it belonged to the eunuch who hanged himself when the last Ming Emperor committed suicide."[12] Reporting on his acquisition in the May 1929 *Pennsylvania Museum Bulletin*, however, Jayne mistook this eunuch for Wei Zhongxian, the infamous attendant to the next-to-the-last Ming emperor, Tianqi (r. 1621–27).[13] Thus, from 1929 until recently the Museum's reception hall was erroneously attributed to Wei Zhongxian when, in accordance with Punnett's statement, it really belonged to Wang Cheng'en, one of the many eunuchs in the service of the last Ming dynasty ruler, the Chongzhen emperor (r. 1628–44).[14] Qing dynasty maps and historical accounts of the residential history of Beijing corroborate Punnett's assertion by revealing that Excellency Wang Alley (Wangdaren hutong) was the site of Wang Cheng'en's official residence; indeed, the street appears to have been named for him.[15]

Wang Cheng'en was employed at the Forbidden City in the high-ranking position of *bingbi taijian* (literally, "brush holder"), which involved transcribing and writing imperial memoranda and other communications under the chief eunuch in the Ceremonial Directorate (one of the twelve agencies under which Ming dynasty eunuchs worked).[16] In 1642 he became superintendent of the city garrison, and in 1643 he was made supervisor of the capital barracks. It would have been during this time, when he was gaining high-ranking positions in the service of the emperor, that Wang Cheng'en had his palatial complex built in the northeastern part of the Inner City (fig. 7).[17] However, the Chongzhen emperor's reign ended prematurely, due in part to natural disasters and peasant uprisings. In 1644, as peasant troops led by Li Zicheng (1606–1645) occupied Beijing, the emperor fled the imperial palace with Wang Cheng'en. When they reached Longevity Hill in a nearby imperial park, the emperor and his loyal eunuch hanged themselves side by side, dramatically marking the end of the Ming dynasty.[18]

What happened to the palace immediately following Wang Cheng'en's death is not known, but later in the Qing dynasty his residence became the palace of Hongwei, the tenth son of Yunreng (1674–1725), who himself was the second son of the Kangxi emperor (r. 1662–1722). In 1739, Hongwei inherited the title of Prince Li. After he had

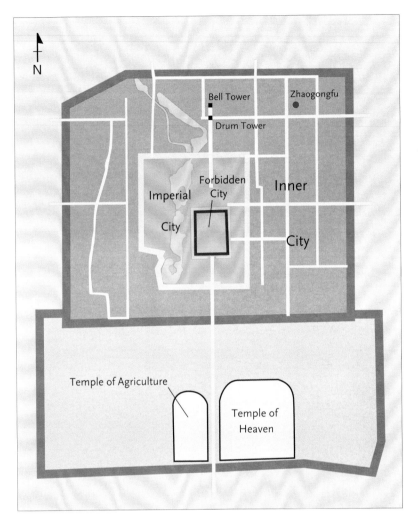

Fig. 7. Simplified map of Beijing indicating the location of the Zhaogongfu in the northeastern part of the Inner City

moved into the palace on Excellency Wang Alley, it became known as the Prince Li Palace (Li junwang fu), but it is not known how long he occupied it.[19] In the surviving historical accounts, the last documented resident of the property is a Duke Feng (Feng Gong), who moved there early in the Tongzhi period (1862–74).[20] During the Xuan-tong period (1909–11), Qing dynasty maps indicate that the name of the eastern segment of Excellency Wang Alley was changed to Zhaogongfu (Palace of Duke Zhao).[21] Although it remains unclear why or by whom the name was changed, the change indicates that a Duke Zhao (Zhao Gong) occupied the premises during this period.[22]

In modern times, Beijing has undergone and continues to undergo an enormous amount of new construction. As of the summer of 2001, however, the lane on which the Zhaogongfu formerly stood still existed.[23] A government building, a hotel, and a residential housing project are now among the structures that occupy the area where the palace complex once stood.

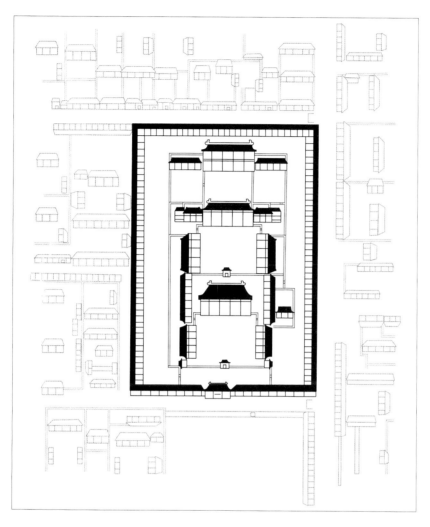

Fig. 8. The Prince Li Palace on Excellency Wang Alley, after a reproduction of a 1750 map in *Jia mo Qianlong jingcheng quantu* (Special Copy of the Complete Atlas of the Qianlong Capital)

Courtyard Architecture

During the Ming and Qing dynasties many palatial residences were built in Beijing. The British geographer Sir John Barrow (1764–1848), who visited the city during the last decade of the eighteenth century, wrote that "the house of a prince, or a great officer of state, in the capital, is not much distinguished from that of a tradesman, except by the greater space of ground on which it stands, and by being surrounded by a high wall."[24] A detailed drawing of part of the northeastern corner of the Inner City in a reproduction of a 1750 historical atlas titled *Jia mo Qianlong jingcheng quantu* (Special Copy of the Complete Atlas of the Qianlong Capital) shows that what was then called the Prince Li Palace on Excellency Wang Alley was enclosed by high walls, as well as a roofed gallery running along the inside of the walls (fig. 8).

The plan of the palace was in keeping with traditional Chinese courtyard residences, where the buildings are arranged on a north-south axis, with the front gate-

ways of the complex situated to the south. The residence had three courtyards, each separated by a main building that was five bays wide. The private dwelling quarters surrounded the inner courtyards and were located in the northern part of the complex.[25] According to the atlas, the northernmost building of the residence had two stories; since the reception hall was only one story high, it must have been either the front or the middle building of the complex.

Visitors would have presented their names at the main door of the compound, after which a servant would have led them from the public to the private spaces of the dwelling in accordance with their social position. Outsiders such as peddlers were kept waiting at the entrance, while friends, relatives, and associates were more likely to have been received in the first courtyard or in the reception hall itself. As visitors to the palace on Excellency Wang Alley passed through the main entrance to the reception hall, they would have been impressed by the hall's stately appearance. The building's horizontal simplicity, combined with brick exterior walls, a steep roof covered with ceramic tiles, and straight eave and ridge lines, gave it a monumental quality characteristic of Ming dynasty architecture.

Ancient written accounts, sculptural models and paintings, and archeological excavations all show that the basic structure of Chinese courtyard architecture has remained largely unchanged for more than two thousand years. Like most Chinese buildings, the reception hall was constructed of wood and brick.[26] During the Ming dynasty, a dwelling's scale was determined by sumptuary laws, which mandated that the size of a residential palace be based on the societal rank of its owner. According to these regulations, common residences could be up to three bays wide; an official's building could span five to seven bays; and an imperial palace could be as large as eleven bays.[27] Wang Cheng'en's elevated position allowed him to construct a reception hall that was originally five bays wide. The hall, like all larger Chinese buildings, consisted of a timber frame on a stone platform that not only elevated the wooden elements away from the damp ground but also gave the building prominence. The floor and the steps leading up to the main entrance were also made of stone. Supporting wooden columns and roof timbers composed the frame of the building and carried the weight of the heavy tiled roof. Since the brick walls were not weight bearing, wooden lattice doors and windows—covered with oiled paper, silk gauze, pearl shell, or horn—were easily integrated into the structure and allowed daylight to enter the broad interior space.[28] Bright red lacquered timber columns and striking, multicolored roof timbers contrasted with whitewashed walls and gray stone floor tiles. The subtle mix of ornamentation and restraint provided an unobtrusive background for the beautiful pieces of furniture that would have been displayed there.

The reception hall was the most formal space in a residential complex, and various functions took place in it. For example, a family would gather there to celebrate birthdays and anniversaries and to perform Confucian rituals honoring its ancestors. The hall also provided an appropriate setting for formal meetings and entertainment. The Italian Jesuit priest Matteo Ricci (1552–1610), who served at the Ming court during the late sixteenth century, describes the kind of conduct that was typical when a Chinese host received guests in such a hall:

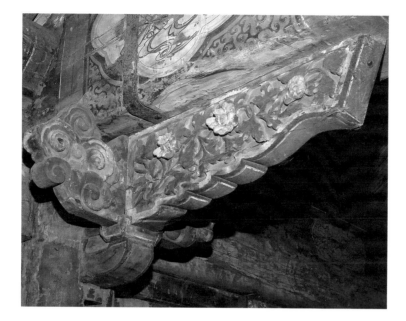

Fig. 9. Detail of a column-head brace carved with peonies. Column-head braces in the reception hall were used for decoration.

The one in charge takes a chair in both hands, and places it in the position of honor for the visitor. Then he dusts it off with his hand, though there will be no sign of dust on it at all. If there are several visitors, he arranges the chairs according to dignity of position in the reception room and then touches each of them with his hands, as it were, to see that they are properly aligned. This gesture is then repeated by all of those who are being visited. The next step in the ceremony is for the principal visitor to take the chair of the host and place it opposite his own, repeating the pretended gesture of dusting it off with his hand. This placing of chairs is then repeated by the other visitors, if there be more, in order of age or of dignity.[29]

The formality of this ceremony would have been enhanced by the enclosed and elegant setting of the hall. There, amid the household's treasures, the master of the house could perform his traditional duties for family and guests alike.

The Interior

The exposed roof timbers of the Museum's reception hall are painted with vibrant decorations, which, with some exceptions, appear almost exactly as they did when the reception hall stood in Beijing.[30] The two large, red pine tie beams, which are its main components, fit into columns that help to support the weight of the roof. Each of these beams is composed of two smaller beams, stacked on top of each other and held together with metal tensile straps to form one large member. Above these, two smaller tie beams are placed horizontally over one another, separated by decorative elements and posts. The purlins run perpendicular to the tie beams and support the rafters, but the decoratively carved, scroll-shaped elements above the beams—a feature that became popular in the fifteenth century—are, like the column-head braces below the beams, primarily ornamental (fig. 9). For some unknown reason, perhaps by mistake, the two largest tie beams were reversed during the installation at the Museum. A photograph of

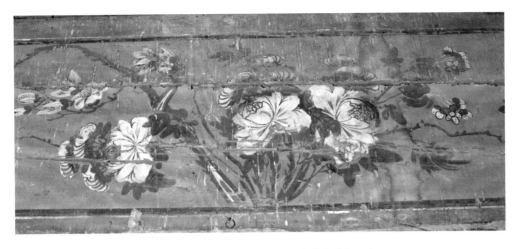

Fig. 10. Detail of peonies painted on the side of the main tie beam to the left of the main entrance

Fig. 11. Detail of a cartouche enclosing a peony on one of the reception hall's purlins

Fig. 12. Detail of peaches painted on the bottom of the main tie beam to the left of the main entrance

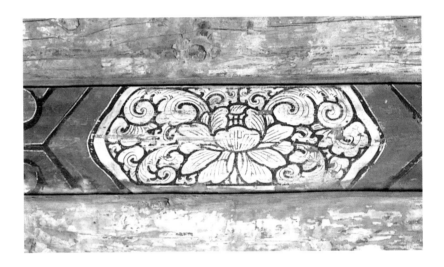

the hall in China (fig. 22) shows the beam closest to the side door to the left of the main entrance decorated with a central frieze of peonies, whereas in the Museum (fig. 1) a central frieze of chrysanthemums is found there.

Today the reception hall's whitewashed walls contrast with the vividly decorated roof, which reveals colors, painted patterns, and styles typical of the Ming and Qing dynasties. The rafters, probably once painted a uniform hue, would have further accentuated the lively designs that symbolize good fortune. Polychrome fruits and flowers, framed by blue and green bands of color and painted on a predominantly green background, decorate many of the timbers. In addition to mallows, camellias, and lilies, the flowers of the four seasons are represented: the plum blossom for winter, the peony for spring (figs. 10, 11), the lotus for summer (fig. 28), and the chrysanthemum for autumn. Peaches, symbolizing longevity, and pomegranates, bursting with the seeds that express a wish for many sons, decorate the lower sides of the two main tie beams (fig. 12).[31] These naturalistic motifs are complemented by abstract whirling patterns. The naturalistic motifs or scrolls of stylized dragons are painted within green, white, or red-orange cartouches (fig. 11). The largest and most centrally placed cartouches on the tie beams enclose floral sprays (fig. 1).

Fig. 13. Detail of the southern ceremonial arch, Ming Tombs, Beijing. From *Zhongguo meishu quanji. Jianju yi shu pian* (Complete Collection of Chinese Art: Architectural Art) (Beijing, 1988), vol. 2, fig. 59.

In China the tradition of decorating roof beams with painted designs has been in practice for over two thousand years, and the motifs that adorn the reception hall originated at various times throughout this long history. The use of cartouches to enclose other decorative elements on the roof timbers became popular during the Song dynasty (960–1279).[32] As seen on the tie beams (fig. 1), the cartouche evolved into a thin band and two thick bands of color during the Ming and Qing dynasties. The convex, tri-lobed ends of the cartouches, which are typical of the Qing dynasty, developed from small, concave scalloped motifs popular during the Ming dynasty.[33] The whirling patterns that flank the cartouches were also extremely popular during the Ming and Qing dynasties and appear to have evolved from decorative motifs that originated in the Yuan dynasty (1279–1368).[34] A variation of this motif is incised on a Ming ceremonial arch near Beijing (fig. 13).

Among the other decorative motifs on the roof beams of the reception hall are paintings of animals in scalloped diamond-shaped cartouches that appear on the ends of both sides of the two main tie beams. Despite some wear, these animals are still visible in seven of the eight diamonds, which contain a bird (fig. 14), a dragon (fig. 15), a tiger (fig. 16), and four distinctive creatures (figs. 17–20). The image in the eighth dia-

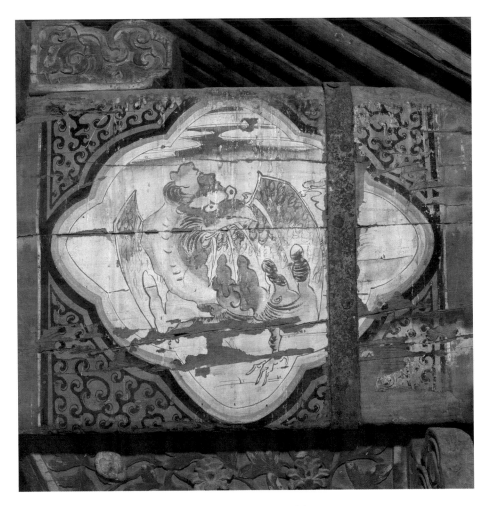

Fig. 14. Detail of a bird painted on the main tie beam to the right of the main entrance

mond is impossible to read. The red bird, the green dragon, and the white tiger often represent directional symbols, signifying south, west, and east respectively. North is typically represented by a "black warrior" (a tortoise intertwined with a snake); it is possible that this symbol was the subject of the eighth diamond.[35] Three of the cartouches with animals also include emblems tied with ribbon. These appear below the dragon and one of the hybrid creatures (figs. 15, 19), while another is tied around the neck of a second beast (fig. 18).[36] The floral decor and all of the creatures and emblems have auspicious connotations in Chinese culture. As one of the most important and formal buildings in the palace complex, the reception hall was appropriately appointed and decorated to assure good fortune and prosperity.

Thick bands of color—green, black, red, and yellow—outline the diamond-shaped cartouche that surrounds each creature. In most instances the compositions have been obscured by paint loss, particularly where pigment once covered the tensile straps that hold these large beams together. Such losses create some confusion, especially when

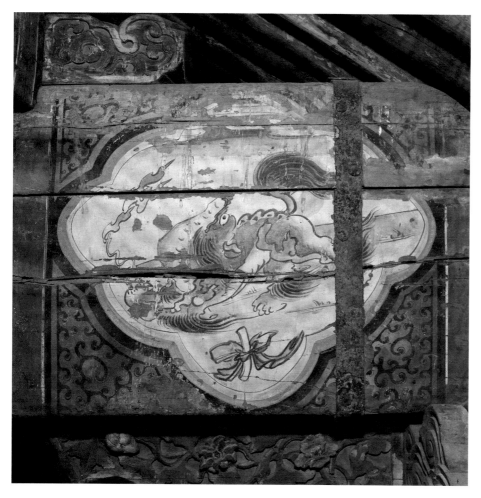

Fig. 15. Detail of a dragon painted on the main tie beam to the left of the main entrance

reading the image of the bird. On the right, the form of the bird is only comprehensible once the viewer realizes that its long tail feathers peek through areas of loss in its extended wing (fig. 14). The bird was executed in vigorous, painterly lines, and it is still possible to discern the variations in brushwork. By contrast, what remains of the tiger (fig. 16) is composed of a combination of wonderfully delicate lines (as seen in its whiskers) and bolder strokes (visible in the animal's stripes and the curving outline of its haunches).

The detailed, calligraphic brushstrokes of some of the creatures contrast markedly with the thicker brushwork of the flowers, fruit, and floral patterns, suggesting that the subject matter determined the kind of technique used, or perhaps that the skill of a painter decided the type of decoration he was assigned. Although the bolder brushwork of the colorful fruit and flowers often appears comparatively impressionistic when observed up close (fig. 11), when viewed from below the effect is both coherent and visually pleasing. Indeed, when seen from a distance, as they were intended to

Fig. 16. Detail of a tiger painted on the main tie beam to the left of the main entrance

Fig. 17. Detail of a horned creature painted on the main tie beam to the left of the main entrance

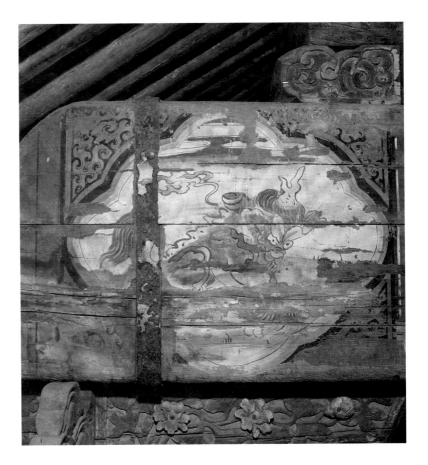

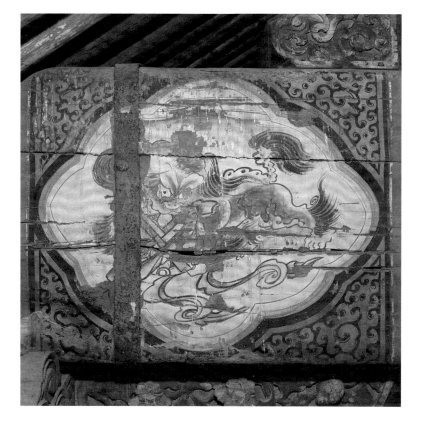

Fig. 18. Detail of a lion painted on the main tie beam to the left of the main entrance

Fig. 19. Detail of a horned hybrid creature with an emblem painted on the main tie beam to the right of the main entrance

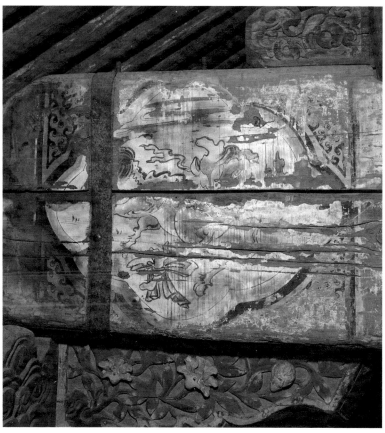

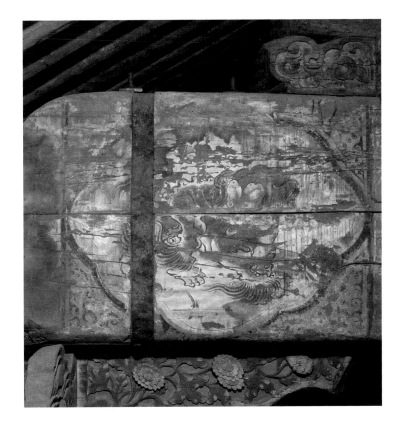

Fig. 20. Detail of a hybrid creature painted on the main
tie beam to the left of the main entrance

be, these dominant floral images function more successfully than the delicately
executed creatures.

Like the history of the structure itself, the reception hall's roof beams have more
than one layer, and like most painted architectural surfaces in China, they were
touched up or modified over time. Surfaces were most often repainted when they
showed signs of deterioration, but in the reception hall even unworn surfaces were
apparently redone. During the conservation treatment of the roof timbers in 1995–96,
different designs and colors were found under the existing layers of paint.[37] Some of
the underlying patterns may be remnants of painting cycles from older buildings, since
it was a common practice in China to reuse wooden elements from other edifices.
However, because these discoveries coincide with our basic understanding of the prop-
erty's history of ownership, it seems more probable that there is a direct relationship
between the paint layers and the owners of the reception hall.

Upon examining various cross sections of paint, conservators and scientists at the
Museum found one partial and two complete paint campaigns on the roof timbers.
The first and unfinished paint scheme is invisible to the naked eye and exists only on
the ridge beam. While it is impossible to determine what the designs in this scheme
were, conservators found remnants of blues, greens, and red, some produced by
expensive mineral pigments such as azurite and vermilion. The second decorative
scheme the conservators found was originally comprehensive: all of the roof beams and
purlins were covered in an overall decoration that included white, gold, red, green,

blue, black, and yellow. This scheme also included raised designs of cranes, incense burners, and scrolling patterns that can still be discerned beneath the current painted decoration. The last paint campaign, which is visible today, has the most varied palette and consists of whites, yellows, greens, blues, reds, black, and brown.

Sumptuary laws regulated both building scale and the use of paint on dwellings, since color also helped to identify and distinguish rank. In the Ming dynasty commoners were not permitted to live in homes with any colored architectural decorations. The elaborate and colorful designs found in all three layers of paint on the reception hall thus indicate that craftsmen decorated it for occupants of considerable social standing. The first painting scheme was most likely commissioned by the original owner, Wang Cheng'en, who held his most powerful positions between 1642 and 1644 and probably owned the property during that very short period. While the unfinished state of this first scheme might be explained by his untimely death, the presence of costly mineral colors is consistent with the monetary rewards attached to Wang Cheng'en's prestigious position. The second decorative scheme, with its elegant raised designs and gold accents, was probably commissioned by the mid-eighteenth-century occupant of the property, Prince Li. As a member of the imperial family, Prince Li would have been sanctioned to use imperial colors, which may explain the presence of gold—one of the colors associated with the imperial line. Finally, the third campaign, with its vibrant and skillfully executed floral and animal motifs, would only have been appropriate in the domiciles of the wealthy. The presence of the tri-lobed cartouches suggests a post-1750 date for this last painting scheme. The owner for whom this decoration was executed may have been the aforementioned Duke Feng, the last documented resident of the hall, or perhaps the Duke Zhao who gave the complex its name very late in the Qing dynasty.

Although the reception hall itself dates to the end of the Ming dynasty, if my conjecture about the decorative cycles is correct, then the painted design visible today was applied during the latter half of the Qing dynasty. More significantly, this rare glimpse at the physical record of a Chinese building's decorative history demonstrates that just as the ownership of a residence could change during the Ming and Qing dynasties, so could the painted decoration that graced a lofty roof.

Conclusion

Owing to the foresight of Fiske Kimball and Horace Jayne, visitors to the Philadelphia Museum of Art are fortunate to have access to significant installations of Chinese architecture, including the reception hall and other period rooms. Thanks to the conservators who worked tirelessly to preserve the reception hall's painted decoration, visitors can continue to appreciate the exquisite craftsmanship of the felicitous creatures, fruits, and flowers, as well as the monumental effect produced by the striking colors, high roof, and wide interior space of the hall as a whole. Indeed, as we gaze at the softly illuminated roof timbers of the Zhaogongfu reception hall today, we too become recipients of the blessings once bestowed on the building's former inhabitants.

Acknowledgments

Numerous people were instrumental to the evolution of this essay. I will mention just a few of them here. Susan Naquin of Princeton University and Lin Xiu of the Capital Library in Beijing provided important guidance during the research phase of this project. Klaas Ruitenbeek of the Royal Ontario Museum and James Watt of the Metropolitan Museum of Art each read a draft of the essay; I have tried to incorporate their invaluable suggestions wherever possible. I would also like to thank Anne d'Harnoncourt, Felice Fischer, Andrew Lins, Sherry Babbitt, and the staff of the Publishing Department at the Philadelphia Museum of Art. Finally this project would not have been possible without the important treatment, research, and boundless patience of my colleagues Sally Malenka and Beth Price.

Notes

1. Horace H. F. Jayne to Fiske Kimball, September 23, 1928, Philadelphia Museum of Art Archives, Far Eastern Art Division, series 3, file "I thru L, 1927–28."

2. Beijing was called Peiping from 1928, when the Nationalists moved the capital to Nanjing, until 1949, when the Communists took over.

3. Horace H. F. Jayne to Fiske Kimball, October 7, 1928, Philadelphia Museum of Art Archives, Far Eastern Art Division, series 3, file "I thru L, 1927–28." The cost equivalent of the reception hall was rendered for 2003 in accordance with the Consumer Price Index (CPI).

4. Jayne to Kimball, October 7, 1928.

5. See Jayne to Kimball, September 23, 1928.

6. Edith A. Punnett to Horace H. F. Jayne, February 12, 1929, Philadelphia Museum of Art Archives, Far Eastern Art Division, series 3, file "M thru P, 1929–30."

7. Ibid.

8. Ibid.

9. The WPA approved $85,000 for the project. See "Brief History of W.P.A. Construction at the Philadelphia Museum of Art, 1935–1937," November 5, 1937, Philadelphia Museum of Art Archives, Fiske Kimball Records (FKR), series 2, sec. 4 (18), file "WPA Projects at Museum, 1936–1940"; Official project description, March 16, 1939, National Archives, WPA Pennsylvania Project Folders, Official Project #665-23-3-628; "The Philadelphia Museum of Art," January 20, 1943, Philadelphia Museum of Art Archives, FKR, series 2, sec. 4 (17), file "Financial Account of Projects, 1938–1943"; Charles J. Commiskey, "Closing Report of Project," May 23, 1940, Philadelphia Museum of Art Archives, FKR, series 2, sec. 4 (18), file "WPA Projects at Museum, 1936–1940." See also David B. Brownlee, *Making a Modern Classic: The Architecture of the Philadelphia Museum of Art* (Philadelphia: Philadelphia Museum of Art, 1997), pp. 108–10. For information on the WPA, see Francis V. O'Connor, *Federal Support for the Visual Arts: The New Deal and Now* (Greenwich, Conn.: New York Graphic Society, 1969), pp. 26–30.

10. "The New Oriental Wing," *Philadelphia Museum of Art Bulletin*, vol. 35, no. 185 (March 1940), n.p. *Philadelphia Museum of Art Annual Report*, no. 64 (1940), pp. 17–20.

11. On February 14, 1936, Jayne wrote to Dr. Gustave Ecke in Beijing asking if it would be possible to obtain approximately 1,500 gray Chinese floor tiles for the Museum: "The Museum has the interior of a late Ming palace room which it is about to erect. Unfortunately, when I purchased this room it did not seem necessary to acquire the floor tiles"; Jayne to Ecke, February 14, 1936, Philadelphia Museum of Art, East Asian Art Department, file "Ming Palace Hall, 29-163-1." In the end, after encountering various difficulties in obtaining the tiles, Jayne decided to use reproductions.

12. Punnett to Jayne, February 12, 1929.

13. Jayne wrote that the hall "comes from Wang Ta Jen Hut'ung [Wangdaren hutong], in the northeastern quarter of Peking. Chao Kung Fu [Zhaogongfu], whence it has been taken, was built by the Chief Eunuch of the *next to last* [emphasis mine] Ming Emperor T'ien Ch'ih [Tianqi]"; see Horace H. F. Jayne, "A Collection of Chinese Paintings Given with an Interior for Their Exhibition," *The Pennsylvania Museum Bulletin*, vol. 24, no. 28 (May 1929), p. 15. Jean Gordon Lee, curator of East Asian art at the Philadelphia Museum of Art 1947–86, upheld Jayne's attribution; see "Chao Kung Fu: Reception Hall from a Ducal Palace, Peking, Early Seventeenth Century," *Philadelphia Museum of Art Bulletin*, vol. 53, no. 256 (Winter 1958), p. 27.

14. Jayne never actually uses Wei Zhongxian's name, but he does make the eunuch's identity clear by the way he describes him; see Jayne, "A Collection of Chinese Paintings," p. 15.

15. On maps of Beijing from 1909–11 and 1917, Zhaogongfu is clearly indicated on the eastern half of Excellency Wang Alley; *Beijing li shi ditu ji* [Record of Beijing Historical Maps] (Beijing: Beijing chu ban she, 1997), pp. 47–48, 59–60. This same area has been recorded as the site of the official residence of the eunuch Wang Cheng'en. See Wang Bin, *Beijing di ming dian* [Dictionary of Beijing Place Names] (Beijing: Zhongguo wen lian chu ban she, 2001), pp. 35–36.

16. Ordinary males were barred from serving in the palace to protect the virtue of the empress and the imperial concubines and to ensure the purity of the imperial lines. Those eunuchs who worked under the Ceremonial Directorate were responsible for doling out punishment, arranging palace entertainment and ceremonies, overseeing special royal missions and eunuch personnel, transmitting and giving advice on petitions, recording imperial documents, and keeping the palace books. See Shih-shan Henry Tsai, *The Eunuchs in the Ming Dynasty* (Albany: State University of New York Press, 1996), pp. 41, 231.

17. For a description of the Inner City, see Evelyn S. Rawski, *The Last Emperors: A Social History of Qing Imperial Institutions* (Berkeley and Los Angeles: University of California Press, 1998), pp. 26–28. Biographical accounts of Wang Cheng'en appear in Zhang Tingyu et al., *Ming shi* [History of the Ming Dynasty] (Taibei: Guo fang yan jiu yuan, 1962), vol. 5, biography 193, p. 3439; and Wang Bin, *Beijing di ming dian*, pp. 35–36.

18. For an English-language account of the fall of the Ming

dynasty, see James Bunyan Parsons, *The Peasant Rebellions of the Late Ming Dynasty* (Tucson: University of Arizona Press, 1970), p. 132.

19. Marked at the eastern end of Excellency Wang Alley on the 1750 Beijing map in *Beijing li shi ditu ji*, pp. 41–42, is the Prince Li Palace (Liqinwang fu). A more detailed view of the Prince Li Palace (Li junwang fu) may be seen in the 1750 map reproduced on leaf *er pai er* of *Jia mo Qianlong jingchen quantu* [Special Copy of the Complete Atlas of the Qianlong Capital] (Beijing: Yanshan chuban she, 1996). This Prince Li is the one who inherited his title in 1739. Zhu Yixin, *Jingshi fangxiangzhi* [Record of the Capital's Lanes and Alleys] (Beijing: Beijing gu ji chu ban she, 1982), p. 175. See also Wang Bin, *Beijing di ming dian*, p. 36. As opposed to the term *fu*, which is typically used to describe the residences of lesser princes or high-ranking individuals, the residences of first- and second-degree princes were called *wang fu*; see Rawski, *The Last Emperors*, p. 107.

20. Zhu Yixin (1846–1894) records Duke Feng's occupation of the palace; see *Jingshi fang xiangzhi*, p. 175.

21. During this period the western section of the area retained the name Wangdaren Alley; see Wang Bin, *Beijing di ming dian*, p. 36; and Zhu Yixin, *Jingshi fang xiangzhi*, p. 175.

22. This Zhaogongfu is different from the residence of the younger brother of the Dowager Empress Ci Xi (1835–1908), also called the Zhaogongfu, which was located near the Lumicang in the northeastern part of Beijing, but to the south of the original site of the Museum's reception hall.

23. In 1965 the name of the Wangdaren Alley was changed to Beixinqiaosantiao (North New Bridge third section). During the Cultural Revolution the name was briefly changed to Hongribeiluliutiao (Red Sun North Road sixth section), but then was changed back. Wang Bin, *Beijing di ming dian*, p. 36.

24. Sir John Barrow, *Travels in China, Containing Descriptions, Observations, and Comparisons . . .* (Philadelphia: W. F. M'Laughlin, 1805), pp. 63–64.

25. The layout of the palace was typical of Beijing courtyard residences, which usually had more than one inner courtyard; see Nelson I. Wu, *Chinese and Indian Architecture: The City of Man, the Mountain of God, and the Realm of Immortals* (London: Prentice-Hall International; New York: George Braziller, 1963), pp. 32–34. See also Werner Blaser, *Courtyard House in China: Tradition and Present*, trans. D. Q. Stephenson (Basel and Boston: Birkhäuser, 1979), p. 10.

26. Prone to destruction by fire and other kinds of natural and human acts, much of this traditional architecture has been lost.

27. Ronald G. Knapp, *The Chinese House: Craft, Symbol,*

and the Folk Tradition (New York: Oxford University Press, 1990), p. 27; Nancy S. Steinhardt et al., *A History of Chinese Architecture* (New Haven: Yale University Press, 2002), p. 247.

28. Barrow, *Travels in China*, p. 222; Wu, *Chinese and Indian Architecture*, pp. 32–34.

29. Matteo Ricci, *China in the Sixteenth Century: The Journals of Matthew Ricci, 1583–1610*, trans. Louis J. Gallagher (New York: Random House, 1953), p. 63.

30. The interiors of Chinese halls either had exposed timbers (as seen here) or coffered ceilings that hid the roof construction (as seen in the Chinese Temple of Wisdom at the Philadelphia Museum of Art).

31. Margaret Medley, *A Handbook of Chinese Art for Collectors and Students* (London: G. Bell and Sons, 1964), p. 96; C.A.S. Williams, *Outlines of Chinese Symbolism* (Peiping: Customs College Press, 1931), pp. 276–77, 299.

32. A tomb in Biancheng, Fenyang County, Shanxi Province, shows an example of this frame from the Song dynasty; see "Shanxi Fenyangxian Beipiancheng Song mu" [A Song Dynasty Tomb in Beipiancheng, Fenyang County, Shanxi], *Kaogu*, no. 3 (1994), p. 286 and pls. 1, 2.

33. Xiao Mo is among the Chinese scholars who have noted the distinctive ends of the decorative cartouches on Ming and Qing dynasty architecture; Xiao Mo, *Zhongguo jian zhu yi shu shi* [A History of the Art of Chinese Architecture] (Beijing: Wen wu chu ban she, 1999), vol. 2, p. 866. Examples of the scalloped motif from the Ming dynasty are visible on a marble ceremonial arch that leads to the Ming tombs (Shisan ling) near Beijing (fig. 13).

34. A Yuan dynasty precedent for the flanking motifs appears in tomb murals in Nanping, Fujian Province. Interestingly, the murals in this tomb were painted to look like architectural interiors, complete with beams and floral motifs; see Zhang Wenyin and Lin Weiqi, "Fujian Nanpingshi Sanguantang Yuandai jinian mu de qingli" [Taking Stock of a Yuan Dynasty Memorial Tomb at Sanguantang in Nanping City, Fujian Province], *Kaogu*, no. 6 (1996), pp. 48, 49. For a more thorough discussion of painted designs on Ming and Qing dynasty architecture, see Institute of the History of Natural Sciences, Chinese Academy of Sciences, *History and Development of Ancient Chinese Architecture* (Beijing: Science Press, 1986), pp. 252–88; and Xiao Mo, *Zhongguo jian zhu yi shu shi*, vol. 2, pp. 853–71.

35. It also may be that these creatures did not have a directional function in the context of the reception hall.

36. These bear some similarity to the Eight Precious Things and Eight Taoist Emblems; see Medley, *A Handbook of Chinese Art*, p. 92, pls. 12, 13.

37. See Malenka and Price, table 1 below.

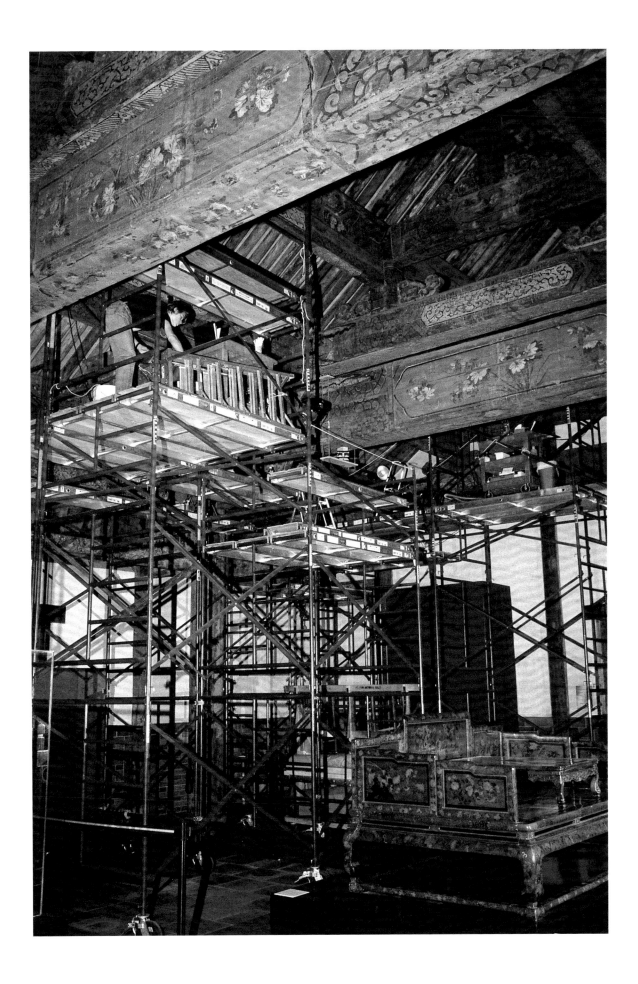

The Chinese Reception Hall: Research and Conservation of the Painted Decoration

SALLY MALENKA

BETH A. PRICE

In a special edition of *The Art News* devoted to the opening of the Asian galleries at the Philadelphia Museum of Art in 1940, Horace H. F. Jayne, curator of Asian art, proudly described the Museum's Ming dynasty reception hall as "the finest single architectural unit ever to leave China, of extraordinary yet restrained splendor which will be long visited and long remembered" (fig. 21).[1] Speculation in *The Art News* that the reception hall would have fallen into disrepair in Beijing if it had not been acquired by the Museum is given credence by photographs of the building in situ (figs. 5, 22) and an eyewitness account describing the residential complex of which the hall was a part as "quite in ruins."[2] The Museum's commitment to the preservation of the reception hall, however, could not simply end with the acquisition and installation of the building. For many decades the hall was admired for its grandeur and extraordinary painted decoration but overlooked in terms of understanding the painting materials and techniques and the unrelenting forces of deterioration to which the paint had been subjected over the centuries. A 1985–86 study of architectural interiors in the Museum raised serious concern that much of the paint decorating the reception hall was flaking and in danger of loss.[3] It would take another ten years of investigative research and conservation treatment before the Museum and its visitors could be assured of the long-term preservation of this magnificent hall.

The Chinese reception hall at the Philadelphia Museum of Art stands without peer in any Western museum. However, as exceptional as it appears to us today, it is a typical Chinese raised-beam construction, built according to a standardized plan and characterized in part by a curving roofline and exposed timbers and pillars.[4] The hall, as it stands now, measures 45 feet wide by 35½ feet deep, and, at its peak, reaches 26 feet in height.

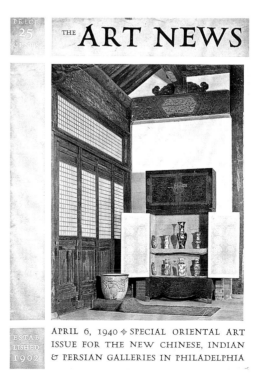

Fig. 21. Cover, *Art News*, April 1940. This issue, which focused on the newly opened Asian galleries at the Museum, featured the Chinese reception hall in two of its five articles.

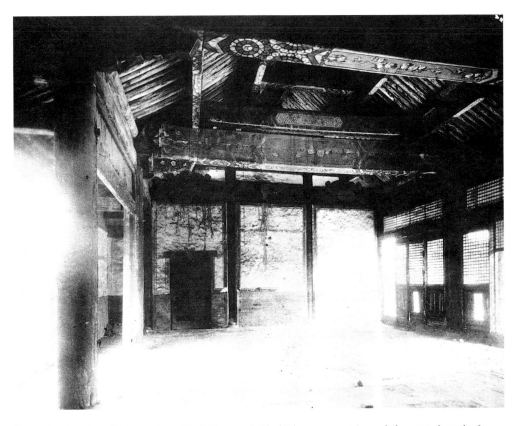

Fig. 22. Interior view of the reception hall in Beijing, 1928. The broken screens, stains, and plant growth on the far wall suggest the poor condition of the building.

It occupies approximately 1,600 square feet and is divided into three bays. A complex system of more than a hundred wooden elements—columns, tie beams, purlins, and posts—was engineered to support the rafters and a tile roof, which is no longer extant (fig. 23). Sixteen wooden columns are joined by four sets of tie beams of diminishing lengths.[5] Each of the two largest tie beams, made of two timbers strapped together with iron bands, measures 31 feet long by $1\frac{1}{3}$ feet wide by 2 feet high and is estimated to weigh more than a ton. Eight sets of 14-foot-long purlins span the width of each bay and support the rafters that provided the frame for the original tile roof.[6] The building does not include the elaborate bracket-set components (*dougong*) used to support beams and eave purlins in many Chinese structures, and the small carved column-head braces under its main tie beams are primarily ornamental. The gentle curve of the roof, which is more noticeable in photographs of the exterior (fig. 5), was determined by the differing heights of the king and queen posts.[7] The weight of the roof timbers was transferred to the columns, so the walls did not need to be load bearing. This traditional Chinese construction method allowed the front wall to be composed of a series of wooden lattice screens. The other walls, made of plaster and brick, were reconstructed in the Museum's installation and are visual approximations of those in the original construction.[8]

The beams, purlins, and posts are joined together by sophisticated interlocking dovetails and mortise-and-tenon joints. Chinese characters written in ink directly on

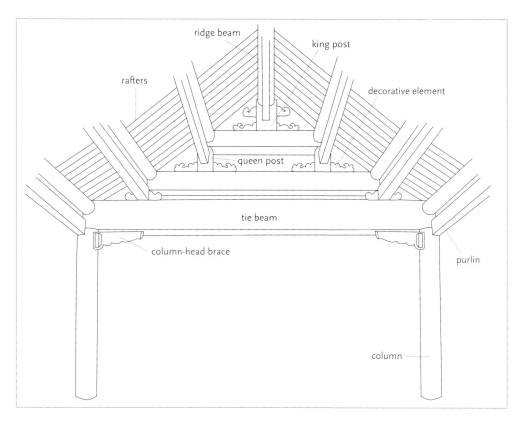

Fig. 23. The architectural terminology applied to the reception hall

the wood before it was painted apparently guided the original assembly (fig. 24). However, the standardized size and joinery of the architectural elements led to inadvertent changes when the room was reassembled in Philadelphia. Photographs of the reception hall when it was still standing in China indicate that the main tie beams were turned 180 degrees when they were installed in Philadelphia. In addition, indentations on some of the purlins, caused by the weight of the rafters and the tile roof, reveal that these too were repositioned during the installation process (fig. 25).

The impressive exposed timber construction of the hall commands the attention of the visitor not only by its scale but also by the colorfully painted ornamental designs that cover more than 4,200 square feet. All the wood surfaces were painted except for the tops of the beams, since they would not have been visible to a person standing in the hall. The design motifs range from auspicious animals to flowers and fruits to stylized dragons; they are depicted in a rich palette of blue, green, orange-red, white, black, red, and yellow (fig. 26).

Historically, Chinese architectural decorations were either sketched or painted directly on the beam or transferred with the aid of a pattern that was traced or pounced.[9] In the reception hall, the craftsmen appear to have employed a variety of methods. The formal symmetry of repeated and regularly spaced decorations, such as the dragons and peony designs, indicates that the layout was planned and the designs

Fig. 24. Characters written on a queen post presumably referring to the placement of the wood element. The translation of the top character is "right."

Fig. 25. Indentations on top of a purlin were caused by the weight of the rafters and tile roof. This indicates that the purlin was repositioned when the hall was erected in the Museum.

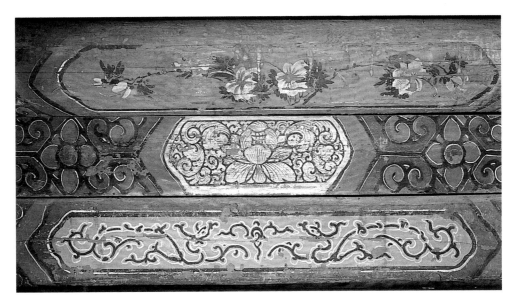

Fig. 26. Design motifs decorating the purlins include flowers in the green cartouche (top), a peony blossom framed in blue (middle), and stylized dragons in the orange-red cartouche (bottom). Such design motifs appear in regular symmetrical patterns throughout the ceiling.

were transferred by use of a pattern. In contrast, each of the many floral and fruit designs on the purlins is unique and appears to have been painted freehand, perhaps guided by reference to a repertoire of master drawings. The scale and sophisticated composition of the flowers and auspicious animals on the main beams suggest that while some technique was used to guide the layout of the design, the painting itself, with its fluid and fine lines, must have been executed by highly skilled craftsmen.

After the layout of the design was planned, the craftsmen painted the background first, then built up the motifs in layers. Each layer was allowed to dry and probably polished with abrasives or a damp cloth to even the surface and eliminate brush strokes before the next was applied. In many areas the craftsmen painted in broad brush strokes of pure color without tinting or shading. Fine brushwork and thin washes of color with variations in transparency were used for the animal designs and flowers on the main beams (fig. 27). Thin washes were also used to convey a sense of form and volume in the fruits and flowers. Interestingly, in one area the craftsmen employed an unusual technique to render the veins of the leaves: instead of building up the layers of paint, they scraped it away to reveal a contrasting underlying color (fig. 28).

In order to preserve the painted decorations, the conservators needed to establish an approach that would reflect knowledge of the artists' materials and respect for the original painted surfaces. The development of a conservation treatment plan was guided by historical research, review of published studies of similar objects, and visual and scientific examinations of the room. Relatively few

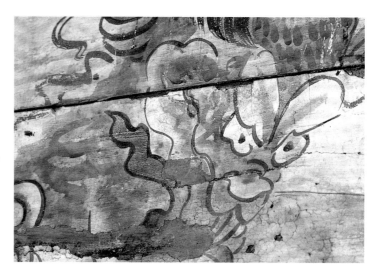

Fig. 27. Detail of one of the auspicious animals on the main tie beam to the right of the main entrance. The animals are painted with a fine line and thin washes of color.

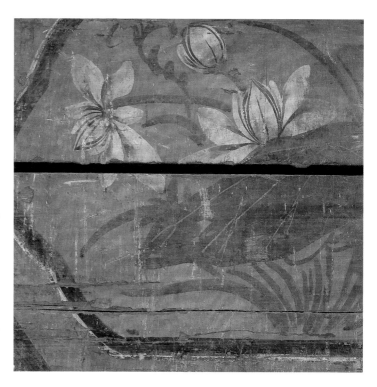

Fig. 28. A lotus leaf design on a tie beam to the right of the main entrance. The veins of the leaf were made by scraping away the black wash to reveal the light green underlying layer.

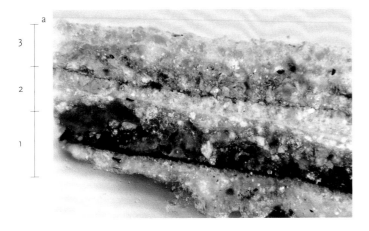

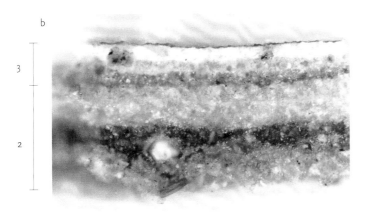

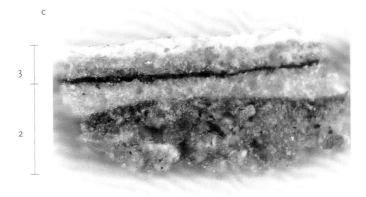

Fig. 29. Photomicrographs of paint cross sections:
a. Sample from a green cartouche on the ridge beam. This cross section includes the earliest painted decoration, which was blue in this area (1). The area was later repainted green two times (2, 3). (10 × objective ≈ 612 μm thick)
b. Sample taken from a red and white floral design in a green cartouche on a purlin. The section shows that this area had originally been painted green (2). Note that the earliest decoration as seen in (a) is not present on the purlin. (10 × objective ≈ 462 μm thick)
c. Sample from a floral area on a main tie beam. The stratigraphy is consistent with that of (b). (10 × objective ≈ 369 μm thick)

publications specifically describe the painting materials and techniques for Chinese wooden architecture.[10] Studies of related art forms, such as Chinese wall paintings and polychrome sculpture, provided useful comparative information, although that research has focused mainly on works from earlier dynasties.[11] Given this limited body of information, a comprehensive technical investigation was required to determine the specific materials used to create the decorative surfaces.

Scientific examinations of works of art such as the painted surfaces of the reception hall depend on a combination of sophisticated instrumental and microscopy methods. Each analytical method contributes to a body of evidence that, when taken together, allows for the identification of artists' materials and methods. This in turn provides the information necessary to understand both the current condition of the work and how it appeared in the past. For this study, more than one hundred microscopic paint samples from representative but inconspicuous areas were analyzed. The sequence of paint layers and decorative cycles was revealed in cross sections of the paint samples using visible and fluorescence light microscopies (VLM and FLM). The composition of the paint, which is made up of a binder into which colorants (pigments and dyes) and fillers are dispersed, was determined by scientists using electron probe microanalysis (EPMA), polarized light microscopy (PLM), X-ray diffraction (XRD), Fourier transform infrared microspectroscopy (micro-FTIR), gas chromatography–mass spectrometry (GC-MS), and reverse phase–high performance liquid chromatography (RP-HPLC).[12]

Analysis of the paint samples showed that the timbers of the reception hall were repainted infrequently during its three-hundred-year history. The sequence of layers in the paint cross sections reveals two

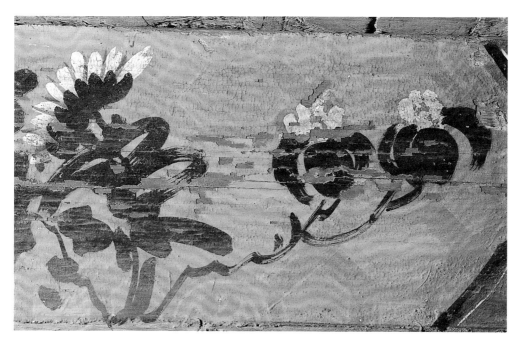

Fig. 30. An example of an earlier design—a turtle-back pattern with cranes—that is visible through later decorations

decorative cycles on most of the roof timbers and three on the central ridge beam (fig. 29). The significance of this finding should not be underestimated, as it is often assumed that architectural interiors were more frequently repainted in China.

The earliest decorative cycle is present only on the ridge beam. We can only speculate as to why this paint cycle is not found elsewhere. One possibility is that the nine timbers that make up the ridge beam were salvaged from a different painted building, while all the other timbers were unpainted or scraped clean. Wood was a valuable resource, since much deforestation had occurred in China over the centuries, and standardized architectural plans allowed timbers to be reused readily in new constructions. Another possibility is that the earliest paint cycle found on the ridge beam was originally intended to cover all of the exposed timbers, but that painting was abruptly halted for unknown reasons. When it resumed, a new decorative scheme was applied to all of the wood surfaces, including the ridge beam. We may never be able to explain the restricted application of this earliest paint decoration based on a technical study alone, in part because the disassembly of the building to move it to Philadelphia would have disrupted telling evidence at the junctures of the wood components. However, we do know that this earliest cycle included vivid blue, green, and red decoration.

In contrast to the first decorative cycle, the second cycle covered all of the roof timbers. This cycle, too, is hidden under the painted decoration we see today, so we cannot offer a complete picture of how it appeared. Some tantalizing clues to the design motifs are still legible, however, including cranes, incense burners, and a variety of geometric and floral patterns as well as fields of a single color within several of the cartouches (fig. 30). For this cycle, the craftsmen's palette consisted of blue, green, red, black, white, yellow, and gold.[13]

As intriguing as these earlier paint cycles are, the last decorative cycle—the one visible today—stands as a remarkable example of pre-modern Chinese architectural painting. This repainting may have been necessitated by loss and deterioration of the previous decorative cycle, or it may have been desired because of changes in ownership or in taste and style. While the general design layout, as well as some of the designs themselves, may have been copied from the previous cycle, both the great variety of fruits and flowers in the green cartouches and the auspicious animals on the main beams appear to be unique to this cycle. Here, blue and green dominate the palette, but a range of colors allowed the fruit, flower, and animal motifs to be rendered in a naturalistic style.

Each of the three decorative cycles consists of several layers, visible in the paint cross sections: a coarse ground, a fine ground, and one or more paint layers (fig. 31). The purpose of the grounds was to cover the wood or previous paint layer, filling in irregularities and providing a smooth, compact surface ideal for painting. The fillers and colorants used in the gound and paint layers, as well as their chemical names and formulae, are given in Table 1. Most of the pigments identified in the paint, such as red lead, vermilion, and lead white, have a long history of use in China. However, in general, the colorants found in the last paint cycle, while representing a wider palette, are also less intense and less expensive substitutes for those found in the earlier cycles. For example, the transparent pigment smalt was used in combination with the organic dye indigo to imitate the deep blue pigment azurite, found in the first decorative cycle.

In all three decorative cycles, the paint and grounds were formulated with animal glue as the binder (fig. 32). Such glue-bound paints were traditionally used in Chinese sculptures and wall paintings.[14] Small quantities of conifer resin and trace levels of drying oil were also found in the binder of the paint and ground layers (fig. 33).[15] While these components may have been added intentionally to improve the handling of the paint, the conifer resin may also be an exudate from the pine beams themselves. Distinct from the paint binder, a discrete layer of starch was found between the second and third decorative cycles (fig. 34). This material, possibly rice paste, would have been used to improve the adhesion of the final paint cycle.

Many visitors, when they first see the painted timbers, imagine that the surface was once glossy and that the paint has faded. However, through our analysis of the binder and colorants, we now know that areas where the paint is intact are probably not far from their original appearance, since glue-bound paints are matte or semi-matte by nature (fig. 35).[16] The organic dyes, which are prone to fading, are still bright in such examples as the red and yellow of the flowers. The inorganic pigments, such as those used for the orange and green cartouches, are not susceptible to light fading and do not appear to have altered chemically.[17] The fact that the colorants have not faded significantly can be attributed in large part to the hall's original context in China. The front lattice screens and lamps or candles would have provided low levels of light that would have had little effect on the painted surfaces. Similar light levels have been maintained at the Museum; not only are they appropriate for the historical context of the room but they ultimately benefit the preservation of the paint.

a

3

2

1

Fig. 31. Paint cross section from the ridge beam:

a. Photomicrograph of the cross section showing three decorative cycles. Each cycle consists of multiple layers: coarse ground, fine ground, and paint. In this section, the earliest paint decoration is red (1); the area was repainted green two times (2, 3). (10 × objective ≈ 435 μm thick)

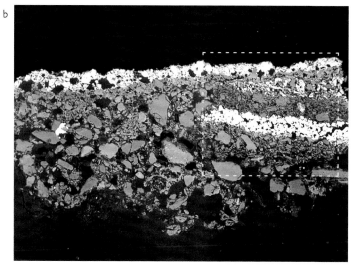

b

3

2

1

b. Back-scatter electron (BSE) image of the same cross section, acquired using electron probe microanalysis (EPMA). In the BSE image, the paint layers correspond to the lighter areas and contain pigments with higher atomic number elements. The ground layers correspond to the darker areas and are composed of clay minerals with lower atomic number elements. The yellow box indicates the BSE detail shown in (c) below.

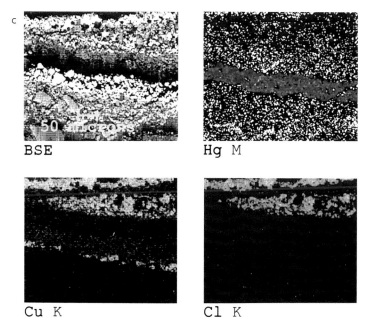

c

BSE

Hg M

Cu K

Cl K

c. BSE detail and colorized X-ray maps acquired by EPMA. These maps show the distribution of the elements mercury (Hg), copper (Cu), and chlorine (Cl) in the paint layers. Hg suggests the red pigment vermilion (HgS), whereas the Cu and Cl are consistent with the green pigments atacamite and/or botallackite ($Cu_2Cl(OH)_3$). X-ray diffraction (XRD) and Fourier transform infrared microspectroscopy (micro-FTIR) were used in conjunction with EPMA to identify these pigments.

Table 1. Colorants and fillers identified in the painted decorations
of the Chinese reception hall

Layer	Color in cross section	Colorant or filler name	Common chemical name/composition
Coarse ground	brown	clay [a, b, d]	alumino silicate / $Al_4Si_4O_{10}(OH)_8$
		quartz [a, b]	silicon dioxide / SiO_2
		feldspar [b, d]	feldspar / $KAlSi_3O_8$-$NaAlSi_3O_8$-$CaAl_2Si_2O_8$
		gypsum [d]	calcium sulfate dihydrate / $CaSO_4 \cdot 2H_2O$
Fine ground	white	calcite [a, b, c]	calcium carbonate / $CaCO_3$
Paint	green	malachite [a, b, c]	basic copper carbonate / $Cu_2(CO_3)(OH)_2$
		atacamite [b, c, d]	basic copper chloride / $Cu_2Cl(OH)_3$
	blue	azurite [a, b, c]	basic copper carbonate / $Cu_3(CO_3)_2(OH)_2$
	blue	indigo [d]	indigo / $C_{16}H_{10}N_2O_2$
	red	vermilion [a, b, c]	mercuric sulfide / HgS

Second decorative cycle

Layer	Color in cross section	Colorant or filler name	Common chemical name/composition
Coarse ground	brown	montmorillonite [a, b, d]	montmorillonite / $(Na,Ca)_{0.3}(Al,Mg)_2Si_4O_{10}(OH)_2 \cdot nH_2O$
		kaolinite (minor) [a, b, d]	kaolinite / $Al_2Si_2O_5(OH)_4$
		quartz [a, b, d]	silicon dioxide / SiO_2
		gypsum (minor) [a, b, d]	calcium sulfate dihydrate / $CaSO_4 \cdot 2H_2O$
Fine ground	black	carbon black [a, b]	carbon / C
		montmorillonite [a, b, d]	montmorillonite / $(Na,Ca)_{0.3}(Al,Mg)_2Si_4O_{10}(OH)_2 \cdot nH_2O$
		kaolinite (minor) [a, b, d]	kaolinite / $Al_2Si_2O_5(OH)_4$
		quartz [a, b, d]	silicon dioxide / SiO_2
Fine ground	white	muscovite [a, b]	muscovite / $KAl_2(Si_3Al)O_{10}(OH)_2$
		quartz [a, b, c, d]	silicon dioxide / SiO_2
Raised decoration	white	calcite [b, c]	calcium carbonate / $CaCO_3$
Paint	green	atacamite [a, b, c]	basic copper chloride / $Cu_2Cl(OH)_3$
		botallackite [a, b, c]	basic copper chloride / $Cu_2Cl(OH)_3$
	blue	indigo [d]	indigo / $C_{16}H_{10}N_2O_2$
		lead white [a, b, c]	basic lead carbonate / $2PbCO_3 \cdot Pb(OH)_2$
		calcite [a, b, c]	calcium carbonate / $CaCO_3$
	red	vermilion [a, b, c]	mercuric sulfide / HgS
	black	carbon [a]	carbon / C
	white	lead white [a, b, c]	basic lead carbonate $2PbCO_3 \cdot Pb(OH)_2$
	yellow	orpiment [b, c]	arsenic sulfide / As_2S_3
		calcite [a, b, c]	calcium carbonate / $CaCO_3$
	gold	gold leaf [b]	gold / Au

Layer	Color in cross section	Colorant or filler name	Common chemical name/composition
Ground	brown	calcite [a, b, d]	calcium carbonate / $CaCO_3$
		gypsum [a, b, d]	calcium sulfate dihydrate / $CaSO_4 \cdot 2H_2O$
		quartz [a, b, d]	silicon dioxide / SiO_2
Fine ground	gray	indigo [d]	indigo / $C_{16}H_{10}N_2O_2$
		calcite [a, b, c]	calcium carbonate / $CaCO_3$
Paint	green	atacamite [b, c, d]	basic copper chloride / $Cu_2Cl(OH)_3$
		botallackite [b, c, d]	basic copper chloride / $Cu_2Cl(OH)_3$
	blue	indigo [d]	indigo / $C_{16}H_{10}N_2O_2$
		lead white, basic [a, b, c]	basic lead carbonate / $2PbCO_3 \cdot Pb(OH)_2$
		calcite [a, b, c]	calcium carbonate / $CaCO_3$
	blue	smalt [a, d]	glass / SiO_2; K_2O;CoO
	orange-red	red lead [a, b, c]	lead tetroxide / Pb_3O_4
	black	carbon [a, b]	carbon / C
	brown	hematite [b, c, d]	iron oxide / Fe_2O_3
	white	lead white [a, b, c]	basic lead carbonate / $2PbCO_3 \cdot Pb(OH)_2$
	red	lac [e]	laccaic acids A, B / $C_{26}H_{19}NO_{12}$, $C_{24}H_{16}O_{12}$
	yellow	gamboge [d]	gambogic acid, analogs / $C_{38}H_{44}O_8$

Notes: [a] PLM; [b] EPMA; [c] XRD; [d] Micro-FTIR; [e] RP-HPLC

Unfortunately, glue-bound paints become brittle with age, can crack and flake from dimensional change caused by fluctuations in humidity, and are water-soluble. Direct water damage caused staining and paint loss to the reception hall in China, probably due to poor maintenance of the building and roof, as indicated by photographs from 1928 (figs. 5, 22). Nowhere is this more apparent than on the rafters, where only small amounts of white and blue paint remain. The paint was also probably brittle and cracked from the seasonal changes in Beijing. The disassembly and relocation of the hall from China to the Museum, as well as the years in storage before it was reassembled, no doubt exacerbated damage and losses to the designs.[18] Fluctuations in temperature and humidity within the Museum prior to renovation of the ventilation systems in the early 1970s contributed to the deterioration. The most significant failure was at the wood-paint interface, where lifting and flaking ultimately led to further paint loss.[19] While some of the paint was in good condition, 75 percent of it was fragile and unstable, making conservation treatment critical.

Fig. 32. FTIR spectrum of reception hall paint binder (top) and reference spectrum of animal glue, a proteinaceous material (bottom). The two spectra match well and exhibit similar bands: amide I and II stretch (1657 and 1539 cm⁻¹, respectively), N-H stretch (3298 cm⁻¹), and amide II overtone (3072 cm⁻¹). Amino acid analysis determined that the type of proteinaceous binder is animal glue. (Reference spectrum 100.A07: Amy Snodgrass and Beth A. Price, *The Gettens Collection of Aged Materials of the Artist: FT-IR Spectral Library and Catalog of the Raw Materials* [Philadelphia: Philadelphia Museum of Art, June 1993].)

Fig. 33. Gas chromatography–mass spectrometry (GC-MS) was used to analyze the binder from the fine ground of the first decorative cycle on the ridge beam. The resulting mass spectrum of a compound with retention time 12.5 minutes (top) is similar to a reference spectrum of dihydroisopimaric acid methyl ester (bottom). The molecular ion peak at m/z 318, base peak at m/z 259 and other abundant ion peaks are typical in the spectra of pimaric-type acids. These acids, as well as abietic acids also detected, indicate the presence of conifer resin in the ground layer. (Reference standard spectrum #78474: *The Wiley 130,000 Mass Spectral Data Base*, Revision A.00.00 [New York: John Wiley and Sons, 1986].)

Curators and conservators established a guiding principle for the conservation treatment that was in keeping with the Museum's mission: preserve the paint on the timbers without altering the original designs of the Chinese craftsmen. Completely repainting the decorations, a traditional restoration technique in China, was deemed inappropriate, since such an undertaking would obscure the original work of the craftsmen. Although paint loss and staining had disfigured some areas, they did not impede an appreciation of the overall decorative scheme and the interior of the hall as a whole. Removal of paint to reveal earlier decorations was not an option, as it would have destroyed information about the last decorative cycle of the reception hall. The decision was made to preserve the decorations by re-adhering the paint to the wood without altering the appearance of

the paint. A two-year testing and planning phase was undertaken to select a stable adhesive and determine the method of application.[20] Small sections of the painted decoration were tested with a range of adhesives, including vinyl acetates, acrylics, cellulosics, animal glues, and starch paste.[21] The factors considered when evaluating the adhesives included working characteristics, toxicity, aging properties, and reversibility or re-treatability. Evaluations were conducted after one month and again after two years to assess both the initial and long-term adhesion of the paint to the wood and the effects that the solvents, adhesives, and application methods had on the paint. The cellulosics, methyl cellulose ether and hydroxypropyl cellulose, were found to be the most effective adhesives.[22] These did not alter the saturation of the colors or the matte quality of the paint. Moreover, they allowed the paint to be softened and manipulated without dissolving or breaking, and successfully reattached it to the wood.

After the adhesives had been selected and a treatment plan developed, elaborate

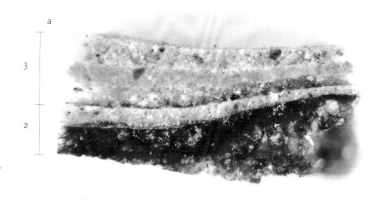

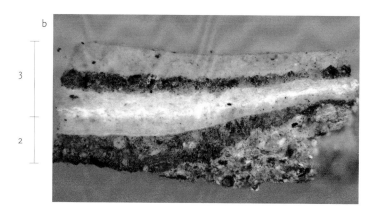

Fig. 34. Photomicrographs of a cross section from a dragon design, taken with normal (a) and ultraviolet (b) illumination. Ultraviolet light illumination (355–425 nm excitation) of the sample causes one layer to fluoresce brightly. This layer, part of decorative cycle 3, was identified by micro-FTIR and polarized light microscopy (PLM) as a starch. It was probably applied to improve the adhesion of the painted decoration. (10 × objective ≈ 381 μm thick)

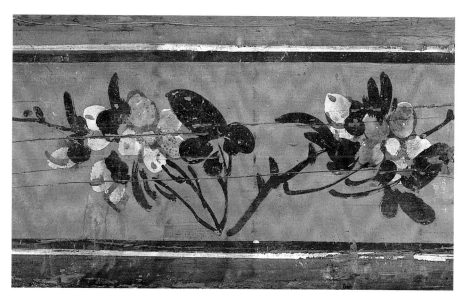

Fig. 35. Detail of a floral design from a purlin. This area is representative of the paint in good condition, where the surface is smooth and semi-matte and the colors are bright.

a

b

c

d

Fig. 36. The treatment steps were as follows: (a) surface dust and dirt removal by vacuum; (b) removal of dirt that had fallen behind the paint film by a brush and mineral spirits; (c) injection of adhesive; and (d) application of gentle pressure and heat through a polyester web barrier with a warm spatula to set the adhesive.

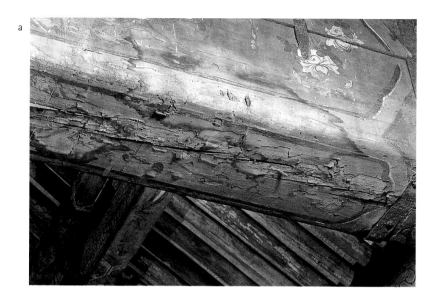

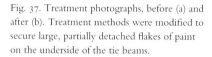

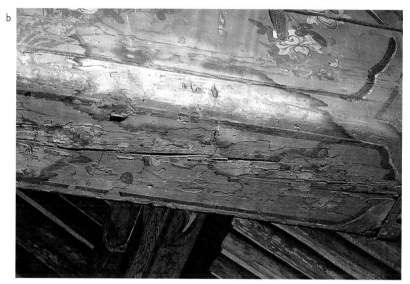

Fig. 37. Treatment photographs, before (a) and after (b). Treatment methods were modified to secure large, partially detached flakes of paint on the underside of the tie beams.

scaffolding was erected in the room, equipment was carried up to the platforms, and a team of conservators and technicians began the painstaking process of re-adhering the paint to the wood. Over the years, dust had accumulated both on and under the flaking paint, and its removal was necessary to facilitate the flow and bonding of the adhesive. This was accomplished by using a soft, dry brush, a low-power vacuum, and a brush dampened with mineral spirits. Adhesive was then injected behind the loose paint flakes with a syringe. Light pressure was applied with a warm spatula to set the flaking paint into contact with the wood and to accelerate the setting of the adhesive (fig. 36). This process was repeated over the course of one year, until the entire 4,200 square feet of painted surfaces had been conserved. The results of the conservation treatment are impressive and can best be appreciated upon close inspection: paint that was severely detached is now secure (fig. 37). Since the completion of the treatment,

the paint has been monitored periodically to ensure that it remains firmly attached to the wood. No new paint losses have occurred.

With the research and conservation treatment completed, we can now reflect on the discoveries that have given us a new perspective on the Chinese reception hall. As we admire its splendid decoration, we can also imagine the earlier layers of rich colors, gold ornamentation, and geometric designs enjoyed by past owners and revealed through modern scientific investigation. Our increased understanding of the painting materials and techniques enhances our appreciation for the many talented craftsmen who transformed the roof timbers of the hall into a magnificent work of art.

Acknowledgments

The authors wish to thank the following individuals for their technical contributions to this study: Edward P. Vicenzi, formerly with the Princeton Materials Institute, Princeton University; Raymond White and Jennifer Pilc, National Gallery of Art, London; Jim Lau, Agilent Technologies; Joe F. Leykam, Macromolecular Structure, Sequencing and Synthesis Facility, Michigan State University; Richard Newman, Museum of Fine Arts, Boston; Peter Eastman, Rohm and Haas Company. At the Philadelphia Museum of Art, special recognition is extended to assistant project conservator Mary Michael Culver, who provided support in all aspects of the conservation treatment, and also to Malcolm Collum, Katherine Forsberg, Marianne Greipp-Walsh, Laranie Hickey-Friedman, Dorothy Krotzer, Lucio Angelo Privitello, Kendra Roth, and Abby Sohn. Sincere thanks are also extended to Andrew Lins, Marigene Butler, Joe Mikuliak, and Jay Martin in the Conservation Department, and Felice Fischer and Adriana Proser in the East Asian Art Department.

The treatment planning phase for the painted surfaces of the reception hall was supported in part by the National Endowment for the Arts, a federal agency. The conservation treatment was supported by The Women's Committee of the Philadelphia Museum of Art and by the Institute of Museum and Library Services (formerly Institute of Museum Services), a federal agency that offers conservation project support to U.S. museums.

Notes

1. A.M.F., "Philadelphia Expands to the East," *The Art News*, vol. 38, no. 27 (April 6, 1940), p. 30.
2. In *The Art News*, Laurence P. Roberts describes the site of the palace complex about a year after the reception hall was purchased by the Philadelphia Museum of Art: "The entrance, before which stood two lion dogs and a venerable tree, was deserted and falling to pieces. The door, however, was securely locked, and no amount of bribing the small children in the neighborhood could unlock it. But I did get a peek over the wall at the grounds. The second building was, of course, gone, being securely stored away in Philadelphia, and the third was quite in ruins" ("Chinese Palace and Galleries," *The Art News*, vol. 38, no. 27 [April 6, 1940], p. 24).
3. Melissa Meighan, "Examination of Ten Period Rooms" (report to the National Endowment for the Humanities), Conservation Department, Philadelphia Museum of Art, 1985–86.
4. Joseph Needham, "Physics and Physical Technology, Part III: Civil Engineering and Nautics," in *Science and Civilisation in China*, vol. 4 (Cambridge: Cambridge University Press, 1976), p. 65.
5. Regis Miller of the United States Forest Products Laboratory, Madison, Wisconsin, identified the wood used for the beams as a species of the red pine group, possibly *Pinus massoniana*; Miller to Sally Malenka, March 30, 1992. J. Thomas Quirk of Quirk Consulting, Madison, Wisconsin, identified the wood used for the columns as also from the red pine group; Quirk to Sally Malenka, October 22, 2002.
6. The rafters typically would have been covered with planks, a lime plaster, and tiles. See Laurence Liu, *Chinese Architecture* (New York: Rizzoli, 1989), p. 30.
7. Needham, "Physics and Physical Technology, Part III," p. 97.
8. A photograph of the building taken around 1928, when it was still standing in China, shows that the walls were beveled to the columns and were decorated with painted bands. The color of the walls and bands was not recorded, and the bands were not reproduced in the Museum's installation.
9. *Pouncing* is a method of transferring a design whereby holes are made in a pattern, which is then placed against the surface to be painted. A bag containing powder is tamped against the pattern and through the holes, leaving an outline of the design. For painting techniques, see Sarah E. Fraser, "Régimes of Production: The Use of Pounces in Temple Construction," *Orientations*, vol. 27, no. 10 (November 1996), pp. 60–69; and Institute of the History of Natural Sciences, Chinese Academy of Sciences, *History and Development of Ancient Chinese Architecture* (Beijing: Science Press, 1986), pp. 270–84.

10. See, for example, Institute of the History of Natural Sciences, Chinese Academy of Sciences, *History and Development of Ancient Chinese Architecture*, pp. 252–88.

11. For examples, see Rutherford J. Gettens, "The Material in the Wall Paintings from Kizil in Chinese Turkestan," *Technical Studies in the Field of the Fine Arts*, vol. 6, no. 4 (April 1938), pp. 281–94; Gettens, "Pigments in a Wall Painting from Central China," *Technical Studies in the Field of the Fine Arts*, vol. 7, no. 2 (October 1938), pp. 99–105; John Larson, "Statue of a Bodhisattva Guanyin," in *The Art of the Conservator*, ed. Andrew Oddy (Washington, D.C.: Smithsonian Institution Press, 1992), pp. 177–89; Ian N. M. Wainwright et al., "Analysis of Wall Painting Fragments from the Mogao and the Bingling Temple Grottoes," in *Conservation of Ancient Sites on the Silk Road*, ed. Neville Agnew (Los Angeles: The Getty Conservation Institute, 1993), pp. 334–40; Francesca Piqué, "Scientific Examination of the Sculptural Polychromy of Cave 6 at Yungang," in *Conservation of Ancient Sites*, pp. 348–61.

12. Instruments used: Zeiss Universal Research polarizing microscope; Wild Leitz Laborlux S microscope; Cameca SX50 electron probe microanalyzer equipped with wavelength dispersive spectrometers (WDS) and a Princeton Gamma Tech IMX energy dispersive spectrometer (EDS); Philips PW1729 X-ray generator equipped with a PW1840 diffractometer and Gandolfi cameras; Nicolet 510P FTIR spectrometer bench and Nic-Plan microscope with an MCT A detector; Fisions VG Trio 2000 MS equipped with a Hewlett-Packard 5850 Series II GC; Hewlett-Packard MS Engine with HP5890 Series II GC; Waters Picotag amino acid analysis system; and Agilent Series 1100 CapLC HPLC system equipped with photodiode array detector, Upchurch Scientific manual microinjection valve, and Zorbax SB-C18 column.

13. Yellow was found in only one sample.

14. See Sally Malenka and Beth A. Price, "A Chinese Wall Painting and a Palace Hall Ceiling: Materials, Technique, and Conservation," in *Conservation of Ancient Sites*, pp. 127–38.

15. For discussion of other paint additives used in Chinese architectural painting, see Institute of the History of Natural Sciences, Academy of Sciences, *History and Development of Ancient Chinese Architecture*, pp. 282, 286–87.

16. The finish of glue-bound paints depends on several factors, including the ratio of pigment to binder. As the paints age, they may become even more matte as light is diffused to a greater degree. Dust and dirt that settle on the surface may also make the colors appear more dull or gray.

17. One such pigment, red lead in glue binder, can darken when exposed to light, humidity, and air. This has not happened in the reception hall. See Elisabeth West Fitzhugh, "Red Lead and Minium," in *Artists' Pigments: A Handbook of Their History and Characteristics*, vol. 1, ed. Robert L. Feller (Washington, D.C.: National Gallery of Art, 1986), pp. 115–18.

18. A comparison of archival photographs of the ceiling taken in China with those taken after the hall's installation in the Museum reveal the extent of the paint loss.

19. The paint appears to have been well formulated by the craftsmen, as almost all the flaking occurs at the interface with the wood, rather than from failure of adhesion within or between the decorative cycles.

20. Sally Malenka, "Report on the Conservation Planning for the Chinese Palace Hall" (report to the National Endowment for the Arts), Conservation Department, Philadelphia Museum of Art, June 9, 1992.

21. Six sections of the decorated timbers, each approximately 11 × 24 inches, were tested.

22. Methocel A4C (1–2% in 50/50 ethanol/water); Klucel G (1–2% in ethanol and 1–2% in 60/40 toluene/ethanol) (all weight/volume). Klucel G (a product of the Aqualon Company) in ethanol or toluene and ethanol was used for the blue paint of the third decorative cycle or as a consolidant for areas with extensive water damage. Methocel A4C (a product of the Dow Chemical Company) was used for all other areas.